D0141596

646.724 G212g
Gaskins, Bill.
 Good and

GOOD AND BAD HAIR

PHOTOGRAPHS BY BILL GASKINS

RUTGERS UNIVERSITY PRESS

New Brunswick, New Jersey, and London

646.724
G 2129

Library of Congress Cataloging-in-Publication Data

Gaskins, Bill, 1953–
 Good and bad hair / photographs by Bill Gaskins.
 p. cm.
 ISBN 0-8135-2475-X
1. Hairdressing of Afro-Americans—Pictorial works. 2. Hairstyles—Pictorial works. I. Title.
TT972.G38 1997
646.7'24—dc21 97-24680

British Cataloging-in-Publication information available

Photographs © Bill Gaskins

Introduction © 1997 by Nikky Finney

Volume © 1997 by Rutgers, the State University of New Jersey

Composition by Ellen C. Dawson

All rights reserved

No part of this book may be reproduced or utilized in any form or by any means, electronic or mechanical,
or by any information storage and retrieval system, without written permission from the publisher. Please contact Rutgers University Press,
Livingston Campus, Bldg. 4161, P.O. Box 5062, New Brunswick, New Jersey 08903.
The only exception to this prohibition is "fair use" as defined by U.S. copyright law.

Manufactured in Canada

KENT FREE LIBRARY

27.00(2430)

BT 121091

Dedicated to William and Eleanor Gaskins

PREFACE

As a child, I remember seeing television commercials advertising hair products. In the 1950s, that meant hair products for white people only. Back then, there were no television advertisements for Black hair products like Dixie Peach Pomade or Murray's Hair Dressing. In all of those ads, I saw only women with hair that shook and bounced; and I wondered why I never saw my father run one of those tiny little combs through his hair.

When a Black child was born, I would hear my mother or other Black women refer to the child's hair as good. They'd say, "That child has a good grade of hair." I don't ever recall hearing them say that a child's hair was bad. But between them and the television commercials, the concept of good hair was firmly set in my mind. Good hair was hair that was not curly or coarse in texture. Good hair was not difficult to comb. Good hair had waves if you were male, length and manageability if you were female. I thought something was wrong with us. We weren't rich, we weren't white, and our hair wasn't on television!

I would grow to learn that we were conditioned to believe that my hair, my family's hair, and anybody's hair that was naturally curly, naturally thick—essentially African—was bad hair. Later in life I would challenge these notions about Black people and our hair. But many a Black child becomes the adult who carries the same unconscious baggage of good and bad hair that I grew up with. This is the man or woman who painfully tries to adapt their hair, and the rest of their body, to an essentially Afrophobic culture, a culture that celebrates a single standard of beauty, a standard that excludes full lips, dark skin, and so-called "kinky" hair.

Today, more African Americans are rejecting the notion that our physical features are ugly or bad, choosing instead to celebrate our essential physical features. One of the most dramatic and diverse expressions of Black self-love and acceptance in recent years has been through hairstyling.

While many African Americans who wear these styles personally reject any cultural connections between themselves and Africa, their hairstyles amount to an unconscious adaptation of traditional African hair adornment—expressing what I refer to as ancestral recall. So regardless of the hairstyles chosen, be it bone straight or a crown of locks, there are African influences on all of those styles.

These photographs bring attention to the symbolic role of hair in contemporary African-American culture and visualize what writer and folklorist Zora Neale Hurston described in her essay "Characteristics of Negro Expression" as our "will to adorn."

BILL GASKINS

TO BE BEHELD

NIKKY FINNEY

There is nothing like being yourself, especially before the eyes of someone who adores you. There is nothing like being yourself and being beheld, especially before the camera of someone who, frame by frame, savors the beauty of who and all he is seeing.

We have adorned our heads from the beginning of time. It is ancient and Black to crimp, coif, and curl in supreme celebration that part of ourselves that lives closest to the sun and other celestial bodies. That most high, most regal part of us has often been what we reach to elaborate on first when we have so much to say about who we are. We adorn this part of ourselves for ourselves mainly, but also for anybody else in the hemisphere needing the visual permission to create some audacious authenticity of style in their own life.

We have tended to this particular body landscape that, consciously or not, holds the cultural jewels of an African sensibility that many have tried to tear from us. We have held on by way of different lengths of cultural memory we see as duty, as responsibility, as the children of genius and many a royal lot, to remember our contemporary lives back through our grandmother and great grandfather's bones. Yes, indeed, we remember ourselves through the ritual of doing and getting our hair done.

Through the sweeping, stacking, locking, and soft methodical construction of our hair, we insist on being seen and we insist on proclaiming more of the knowledge of who we are that we never learned about in any school. This is but one way we catch history that boomerangs back to us and keep our spirits free. Some of us adorn ourselves about the head more elaborately than others. Many of us have always been keen to differentiate our work-a-day world hairdos from our festive world hairdos. Some of us in the tradition of ceremonial embellishing have needed to wait for specific occasions in order to attend to our hair, be it wedding, funeral, or Easter Sunday morning. But the more the world has tried (and succeeded on some levels) to alter the social and physical structures of our neighborhoods where we have not sat in the power seats, the more we bring our free, fancy, elaborate hairstyles to the primary shore of our everyday lives and to the widest mosaic of American life, to say without question I will own the way I look.

There are others of us who have no time to wait for any planned or organized affair, who keep our occasions with us at all times and dare anybody to wonder what it is we got to look so good about. It might simply be our own significant desire to walk to the corner store for an orange soda that makes us want to look a certain way. It could be the need to sit out on the stoop on a Saturday night with the boys and a fresh geometric cut. It could be the thought of one more Monday at the post office on Tenth Street, wearing that same federal uniform that does nothing for her very womanish African hips that makes her upsweep her new braids so that she might be able to hold on to her whole self for the rest of the day.

This family album of *Good and Bad Hair*, photographs by Bill Gaskins, is one of the ways this teacher man, this itinerant, kodachroming, imaging preacher of Black loveliness, loves back on us in the loud. By offering us

these images he reminds us how we must love on ourselves out in the open air of racism and sexism and other isms. Because images are the most powerful things, aside from words, that can be used to steel-wool our soul, the soul of our children, and the soul of our under-siege communities against oppression and in the name of the reconstruction of love, memory, and a proud race presence.

A language is a necessary thing between like-minded life. We need and use it to communicate. Language can be taught and handed down or immediately created out of the implicit need for like-minded life to talk and tell other like-minded life something. Sometimes language has to do with words, sometimes it has to do with hand and body movements, and sometimes it's about how and what we do with our hair. The photographs in this collection create a language of how some Black Americans are expressing themselves by way of their hair—and in so doing, talking and telling anyone within hearing or seeing range, not only the particulars of how beautiful they feel, but also how they refuse to allow anyone to erase their memories or dull their imaginations.

With a photographer's knowing eye, Bill Gaskins walked the various American enclaves where Black folk have gathered for all of this century: New York, Chicago, Atlanta, and Baltimore. He wandered into where Black folk have created modern urban villages and focused on us being ourselves and loved the sight. This recording of Black life is more than personal to Gaskins. As a righteous son and believer in the power and glory of the Black community, he stands not only as recorder but also as witness to the profound cultural languages being spoken by his people, in community, on every level, with their mouths but also with their bodies. He beheld us high in his heart even before he took our picture. The attitude of the human being behind the camera cannot help but reflect through the lens and land in the eyes of the human being waiting in front of the camera. It is so gloriously obvious. Bill Gaskins adores Black folk.

He did not look askance as others had done over the years, assuming that these ones of us celebrating Black hair ebonics didn't have a clue about freedom or the promise of forty acres and a mule made a hundred years before. Gaskins knew his history and everybody else's, while also understanding the privacies and the screams of his home communities. And in my own mind I'd like to believe that he remembered himself back to the day when violent attempts were made, both by local law and civil intimidation, to inevitably control the appearance of Black folks. He knew and he turned to us with his knowing, easily recognizing and ready to honor what he saw in our eyes—the haughty irreverence we have held for hundreds of years of being told what to look like and how to appear, in order that we might be finally acceptable to this most modern image-conscious society. I imagine that Bill Gaskins smiled every time his shutter clicked as he saw us weaving, combing, and styling that same haughty irreverence into our hair. In the name of his mother and his father, with the eyes of his family shining bright, he must have known the treasure of what he was putting away for us, for posterity. He must also have worried, wondering would we treasure and trust our eyes, knowing just how long they have been inundated with racial cataracts.

The power and the beauty of these photographs delights me into a personal grateful frenzy. In this *Good and Bad Hair* family album the subjects and the photographer himself offer us the visual language that has everything to do with aboriginal human memory

recovered strand by strand. Page by page, from city streets to shorelines, my eyes connect with other eyes and this conversation is shared and extended beyond us. This is about faith and pride and connectedness. This is about the actual wearing of that aboriginal memory on that place that is indeed closest to the sun and the stars. These hairstyles and head-dos are the modern representation of something surely passed on by the waves, by the steady, silent, click and shutter of Black bones still rattling out old pictures beneath the very same Atlantic sea that surrounds these urban villages, that holds these Black folk. These vamping escapades of hair have come through the airwaves, too, to a new generation by way of decades of Black family reunions and Black hair expos that take over hotels and convention centers in major American cities, summer after summer. These styles are the modern-day extended version of that old story, of the audacity of Black folk to still trust their imaginations and their twisting brown fingertips to dine most intimately together.

The attending of Black hair on a Black head by Black hands is one of our cultural provisions, something we guard and pack away in order to ensure our truth about our vision of race and cultural memory. The knowing of who and whose we are and have been as one century ends and another takes up right where it left off is always at stake for Black folks in this country. It is not just about emotional and societal marginalization, it is about the attempted massacre of Black spirit, desire, and hope. It is about a national policy of erasure. It has long been the job of many, officially and unofficially, to report and record that we were never really here. This posture will most probably continue on into the next millennium. They will continue to try and say we didn't write anything, we didn't say anything, we didn't create anything, and we therefore didn't leave

anything. I imagine these same individuals taking it a step further by asking where's the proof that we were even here. The proof will always be found in the photographs of the most astute culture bearers. These photographs by Bill Gaskins are the proof.

We are often intellectualized into thinking that as the number of the year we next enter gets higher, the stymied backwards attitudes about race and beauty drop to an all-time low. I say nothing could be farther from the truth. I say we have no choice but to respond as artists and as walking art to the ancient Robesonian question, to either be about slavery or be about freedom. I say these faces on these pages insist on visibility. These eyes and these crook of shoulders say we have been here, we will continue to be, and we have contributed deeply to every area of life in this country. These ones say we are here to stay. And we will not look like everybody else while we do. We still look like ourselves. Because there is nothing like being yourself, because still there rages a 400-year-old race war in full throttle. It is a war about the national disregard for hued skin. A war where a white teacher writes in permanent marker on the face of a little brown girl a message to her mother, reminding her to make sure to wear her glasses to class the next day. It is a war of deep physical and psychological disregard for the preciousness and power of Black skin, Black hair, and Black features. I say pump it up, children. Comb it, swoop it, stack it, drape it. Lovely, yes you are.

The universal beauty ethic of Black folk as I have understood it all of my life has been simply to be beautiful. Period. By any and all ways and means necessary. We have gone through various political and cultural movements that have made this call and response for beauty rise up in different forms with new

terminologies and products. We do without a doubt spend great time, effort, energy, and money on getting and staying in the arms of beauty. And part of the reason we go there so often is in order to get us through our less than fair days. We have for as long as I can recall worn our soul and heart's fire on the tops of our heads as part of our outright audacity as Black folk to claim this part of ourselves as our very own world, with no outside interference.

I believe we have focused on and been obsessed with hair in order to keep our hands and sights on each other. I believe we stay in a groomed state with each other in order to remind ourselves of the language of touch as often as possible, in order to love on each other out loud, as the institutionalized racist world screams for us to turn on each other and keep spewing the hatred that way. At the very same time this world of barber and beauty shops—with names like *Amazon Hair Braiding, Africuts, Khimit Kinks, Brenda's Braids, The African Hair Gallery, Maxamillion* and *Ultimate U*—gives us physical place and spiritual permission to touch, to care, and to tend to each other, if only for a few pampering hours before we have to steel up our hearts again and head back out into that other world. And the styles that come out of these places that honor our hair and our hearts come with a litany of memorable names that defines what Bill Gaskins knows to be truly the "ancestral recall." The roll call of some of the styles prepares us for the deserved adornment that is sometimes only found in the community itself: *Goddess Braids, Silky Dreads, Senegalese Twists, Fishtail Plaits, Bantu Knots, Dukey Braids* and *Fountain Tresses.*

As I turn the pages through Bill Gaskins's pictures, one of the things that I notice most profoundly is how he sees Black women, what the aperture opens and closes around when the picture is actually made for him as vision keeper. Somewhere, skillfully and magically, in between what he sees and the light touch of his finger pressing down, I feel revered as a Black woman. I notice the familiar tilt of her head just so. I recognize the smile right away, giving but never telling all there is to tell, and the proudness silently fluttering in her eyes, knowing that she is finally being seen, being beheld, by someone who has the power. It is then that I know that this man's fingers as a boy somewhere along their way got dipped down deep in a Black woman's healing salve and remembered the feeling and kept it close all these many years. His veneration for Black women is in fact the soft filtering lens used for every photograph herein. There is an honoring of us that comes through as clear as true indigo poured out on a piece of white fabric, an endearing understanding of who a Black woman is when she is seen finally with free, photosensitive eyes.

In these photographs of the elaborately designed, the intricately woven, the precisely shaven, Bill Gaskins asks us to beg the notion that there cannot be only one thing that makes us beautiful. He asks us to challenge that idea as much as he insists we challenge the ridiculous position that there is only one human matrix of beauty, one standard if you will. He knows and we know too that we have not separated the outsides of us from the insides of us. But he is intent and passionate about reminding us to remember what we know, lest we forget, as is the national plan.

We have often as Black folk approached all this from quite the holistic standpoint, even when we haven't always called it that, believing that whatever clothes we have worn for this or that have been as significant as *how* they have been worn, have been as significant as *how* we wear our hair. And all of that kind of thinking has been as full of ritual and reason as that which goes into what we name our children and how

we might plant a tree or a flower when that new baby is born, or how we turn porch chairs down at night so no bad spirit might come and take a rest while we sleep.

This is what I know. This is what I live. And this is what the *Good and Bad Hair* photographs of Bill Gaskins tell me—that no matter what, the circle will never be broken, that every generation will twist and turn the old ways into their own ways, and the next ones of us will step closer to the edge and nudge their locks higher toward the sun, but together we will never fall off or away from each other. This is what I see in these photographs—that memory and tradition is malleable and the circle never breaks between Black folk. Never. This is the language in which these photographs speak to me. As others and even ourselves engage in daily warped conversations about the social firestorms that are bringing so many of us to our emotional and financial knees, there are always countermovements in our communities that are about the work of keeping us buoyant and resilient and alive and in touch with who we are down deeper than any human firestorm could ever scorch.

The heart of loving myself always had to do with loving my Blackness. It had to do with watching so many in my community make so much beauty out of so little. It had to do with style and how pristine my uncles always shined their shoes or my aunties embellished a plain cotton dress until it seemed to shimmer like real gold. It had to do with how we created our art at home and not away from home. It was about how we created it with family and community close by and not by being isolated and off somewhere on our own. It had to do with how we then wore our designs out the back door and down the street to buy a bag of sugar. We didn't

save them for a rainy day. We did not store them away in some box underneath the bed.

This love of creating and being original had to do with how others of us etched our style out in the intricate designs of iron gates or out on the ground in the front yard or on the side or in the back within the world of plants. And it seems to me like I remember Mama saying it was always enough that we could sit at dusk on our porch or our stoop or in front of the mirror and see all that plain, sweet beauty for ourselves, regardless if anybody else ever came down that road or ever said as affirmation "Well now, just look at that. Ain't that something special." We already knew it was special. We had to first know it for ourselves. We had come from people and difficult times where we didn't always have the luxury of being told sweet things while we lived or as we worked. And furthermore, we have always known there is nothing like being yourself. And this is something that has been passed, brown heart to brown heart.

Bill Gaskins walked down that road look-seeing around with his camera hanging easy like a hugging third arm, and he noticed us just out being ourselves and he thought enough about what he saw there to point and click and keep. He saw us plain and simple, elegancized and fabulous, refusing to give up one follicle of control of our hair to anybody but the queen herself, memory. To be Black and beheld by the unflinching eyes and memorizing camera of Bill Gaskins is to understand what Toni Cade Bambara, the writer who loved us as loud with her words as Gaskins does with his photographs, said: "Now here I am and there I am and all I am—Free to be anywhere in the universe."

GOOD AND BAD HAIR

Carolyn, World African Hair Care, Braid, and Trade Show, Atlanta, Georgia, 1997.

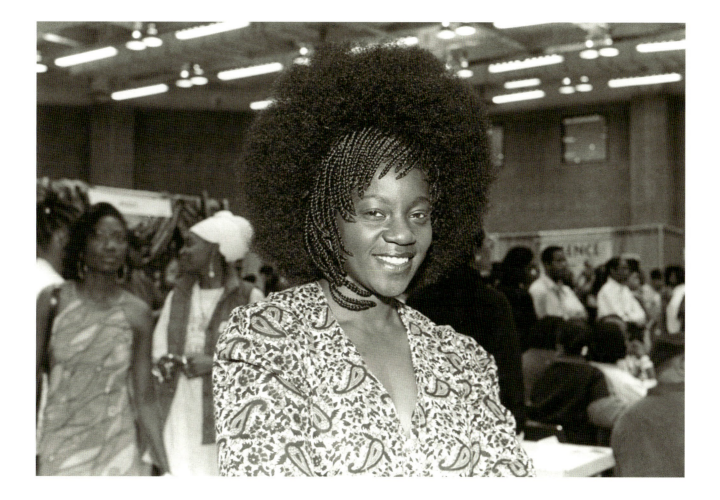

Jennifer, Baltimore, Maryland, 1994.

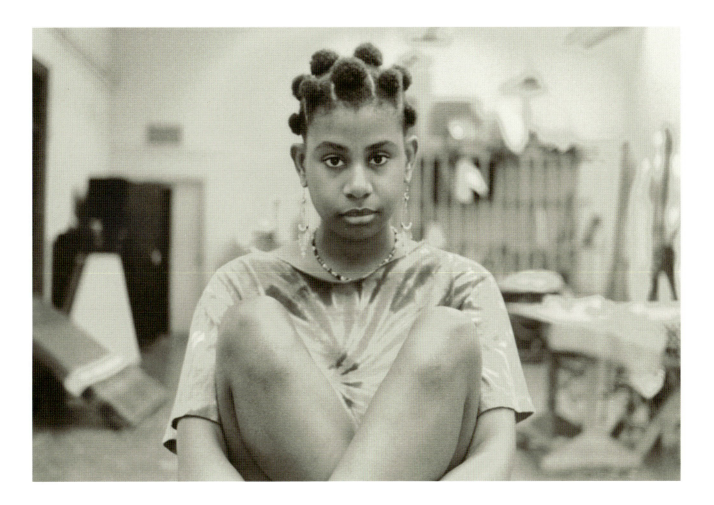

Tony, Northland Mall, Columbus, Ohio, 1991.

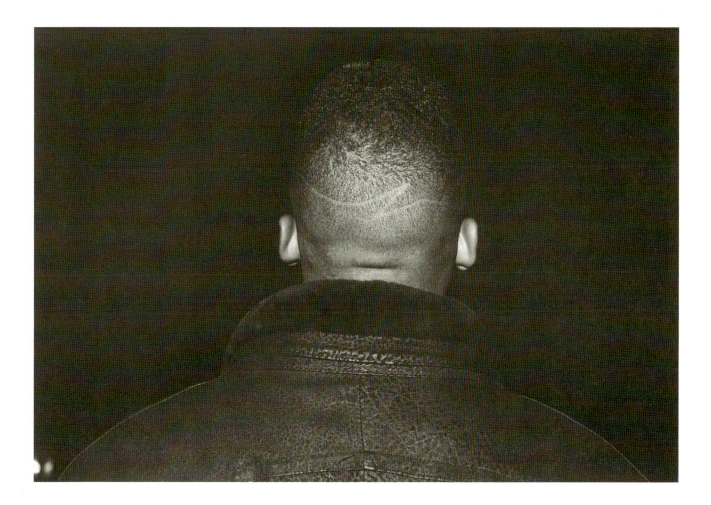

Stylist's model, Proud Lady Beauty Show, Chicago, Illinois, 1994.

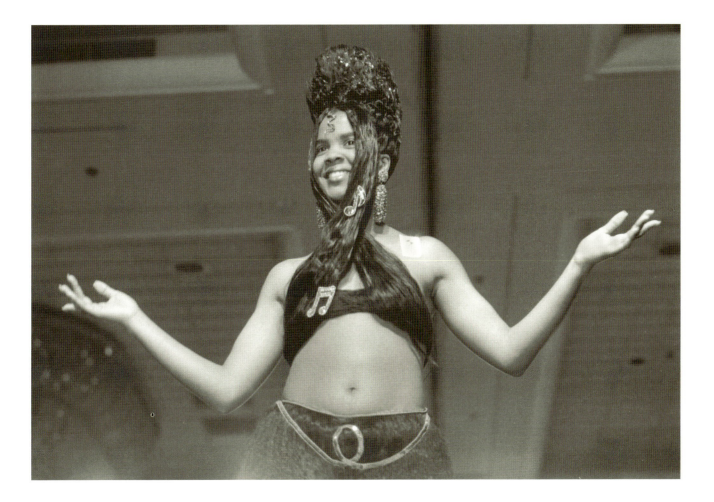

Woman at Black Greek Picnic, Philadelphia, Pennsylvania, 1991.

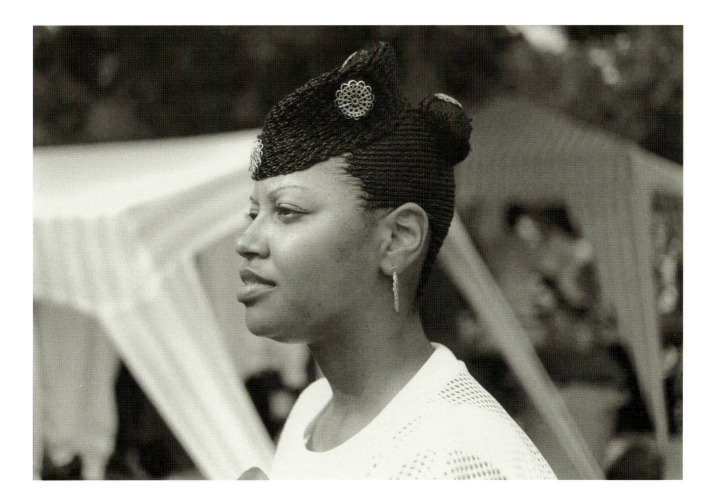

Polo, Columbus, Ohio, 1991.

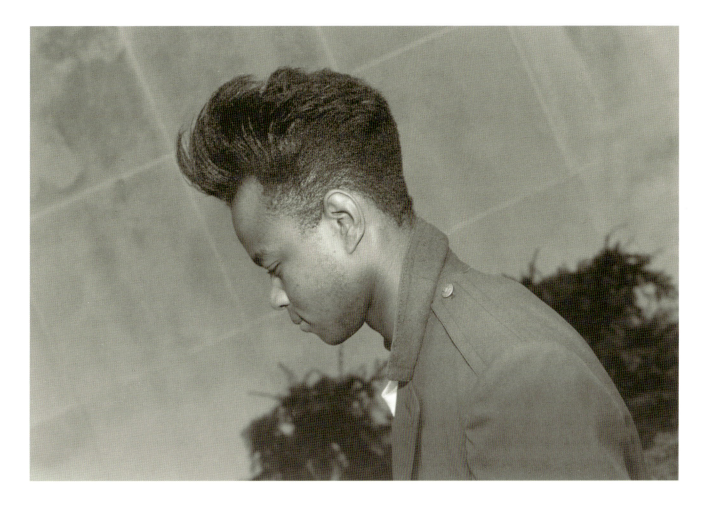

Carol, Union Station, Washington, D.C., 1991.

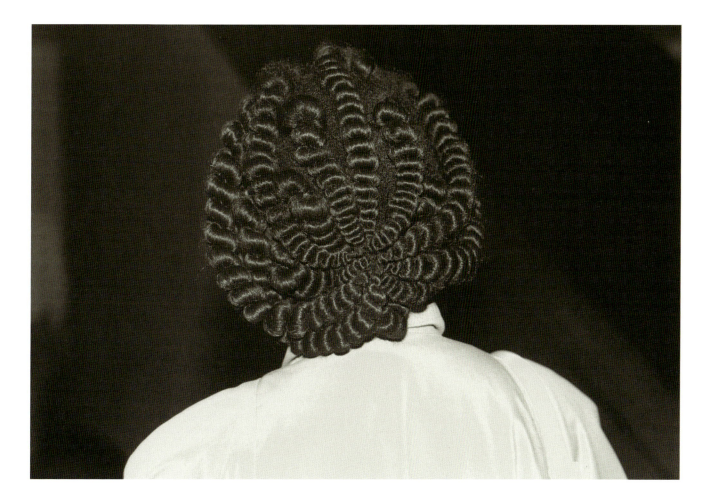

Phyllis, Chicago, Illinois, 1994.

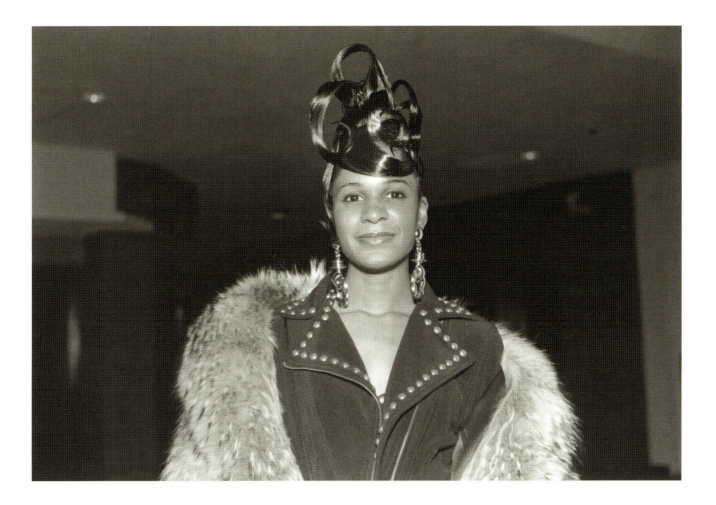

Kareem, Barber, Rochester, New York, 1993.

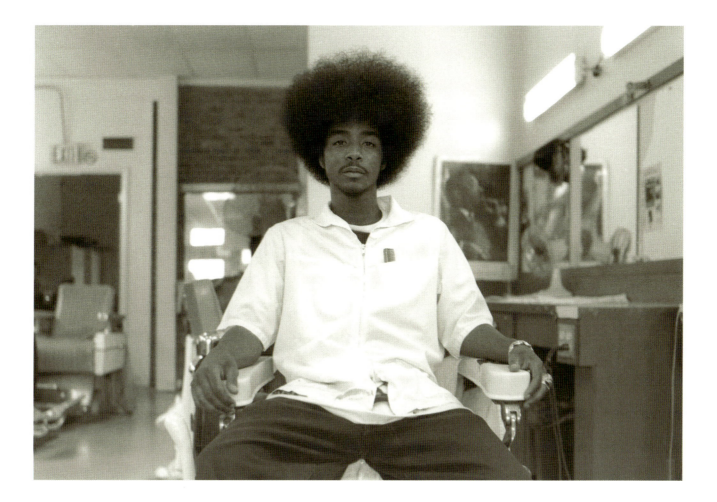

Brenda, Philadelphia, Pennsylvania, 1993.

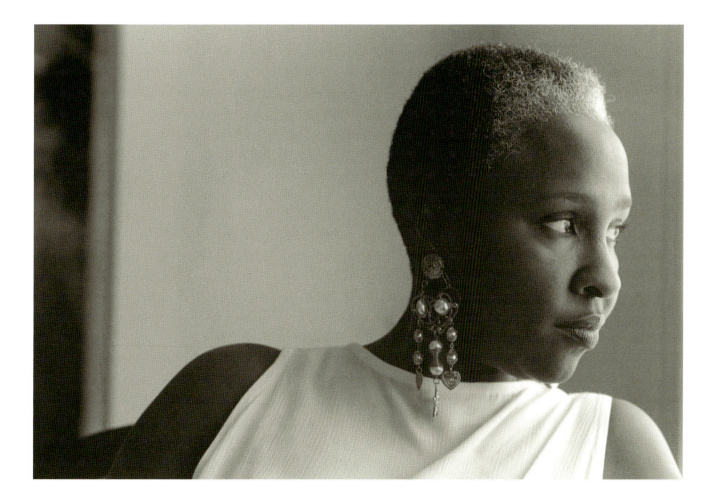

Nikki, Chicago, Illinois, 1994.

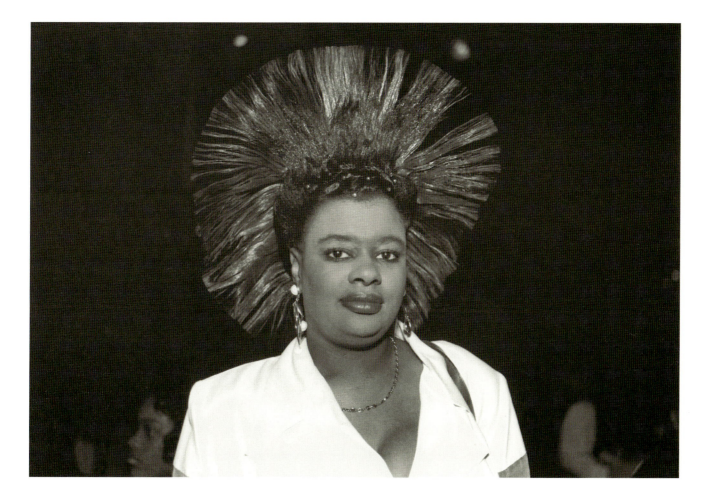

Father and Son, Artscape Festival, Baltimore, Maryland, 1993.

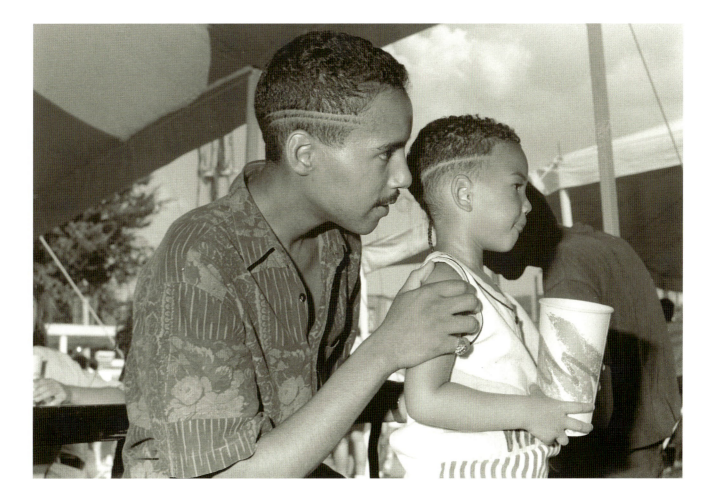

Woman in Gold, Bronner Brothers International Beauty Show, Atlanta, Georgia, 1991.

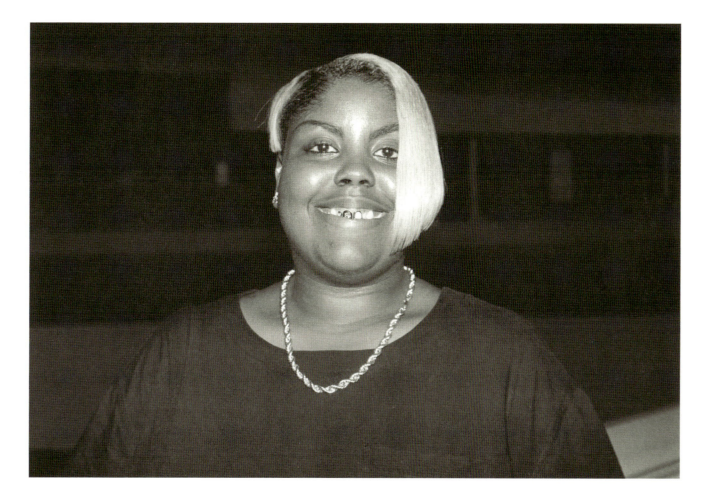

Scarlet, Columbus, Ohio, 1991.

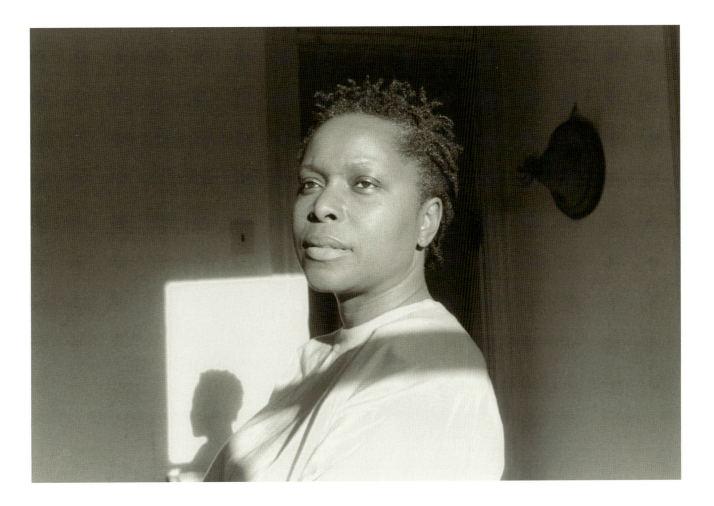

Kenny, Proud Lady Beauty Show, Chicago, Illinois, 1994.

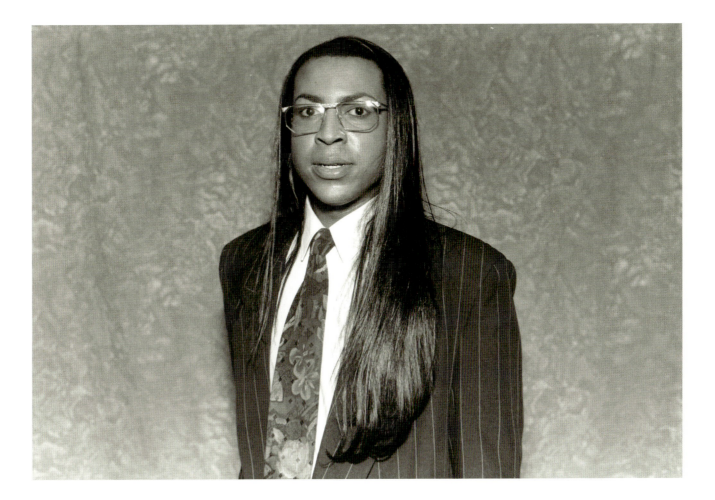

Nicole, Baltimore, Maryland, 1993.

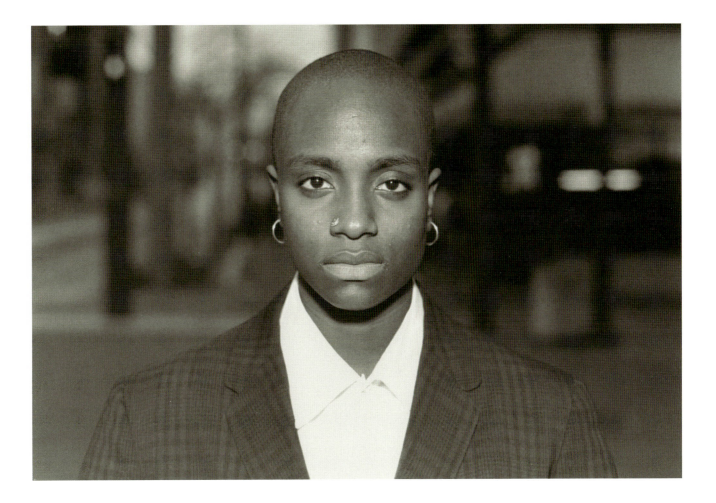

Stylist's model, Proud Lady Beauty Show, Chicago, Illinois, 1994.

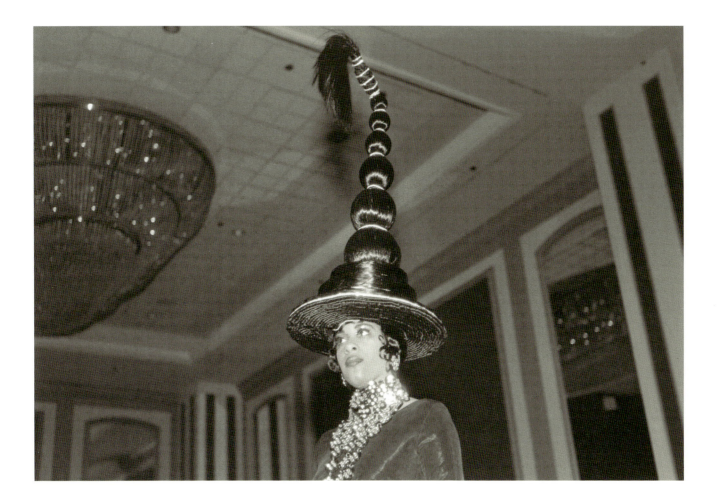

Dennis, Columbus, Ohio, 1991.

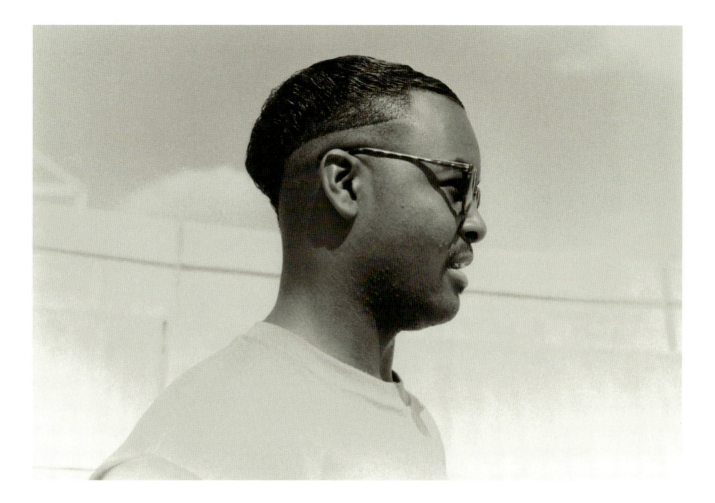

LaToya, Toledo, Ohio, 1997.

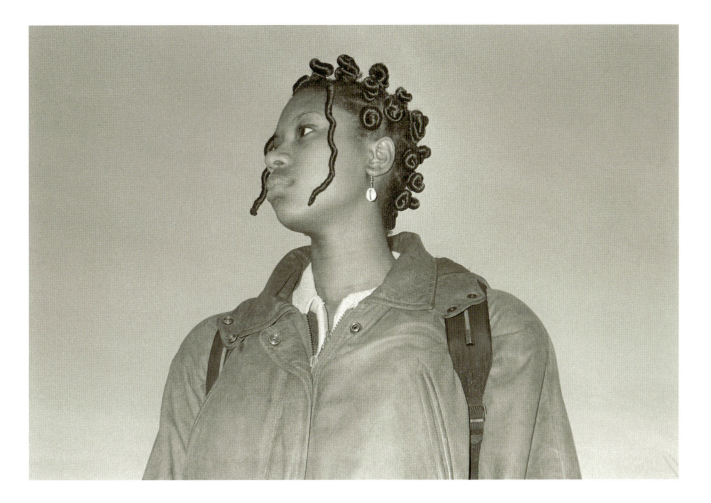

Rosaline, World African Hair Care, Braid, and Trade Show, Atlanta, Georgia, 1997.

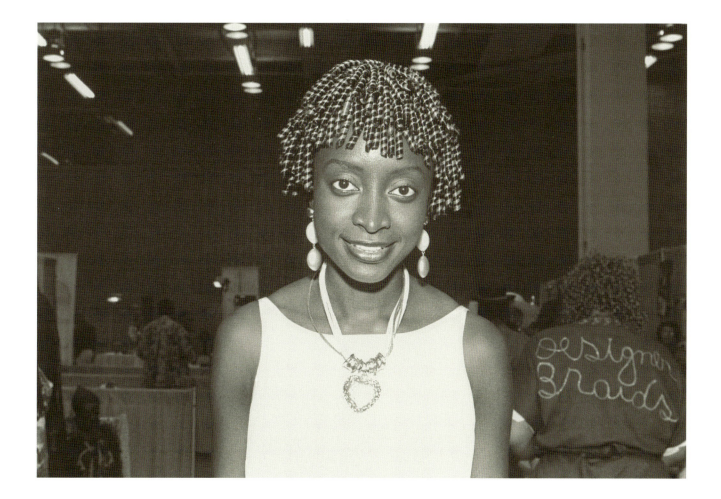

Kevin, Penn Relays, Philadelphia, Pennsylvania, 1994.

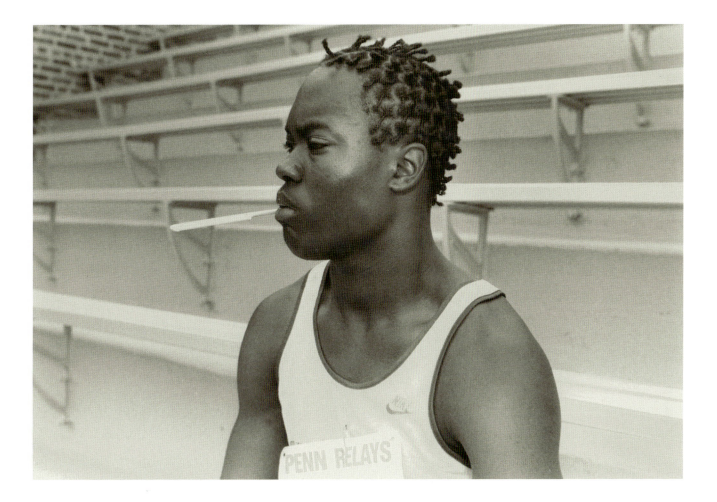

Stylist's model, Proud Lady Beauty Show, Chicago, Illinois, 1994.

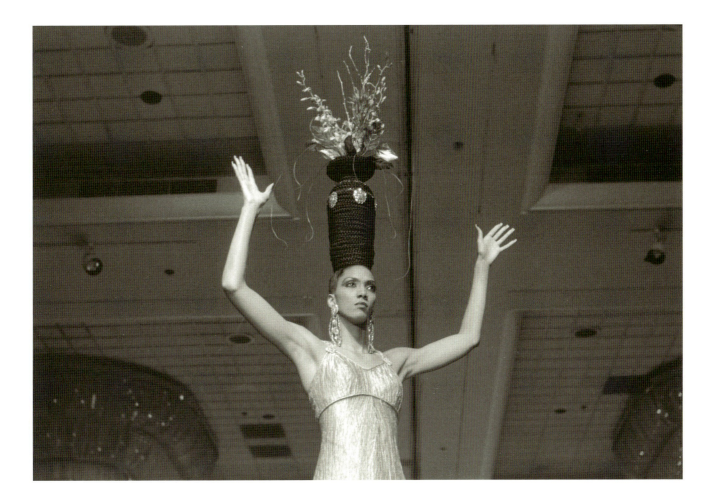

Young Woman at Union Station, Washington, D.C., 1991.

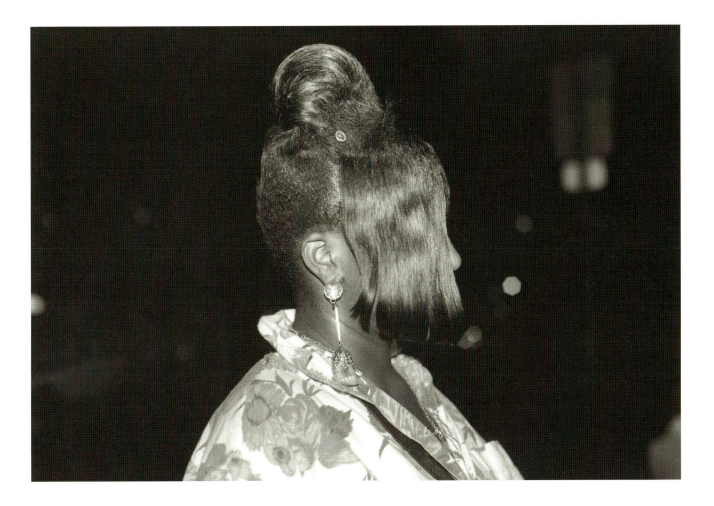

Stylist's model, Spring Hair Show, Columbus, Ohio, 1991.

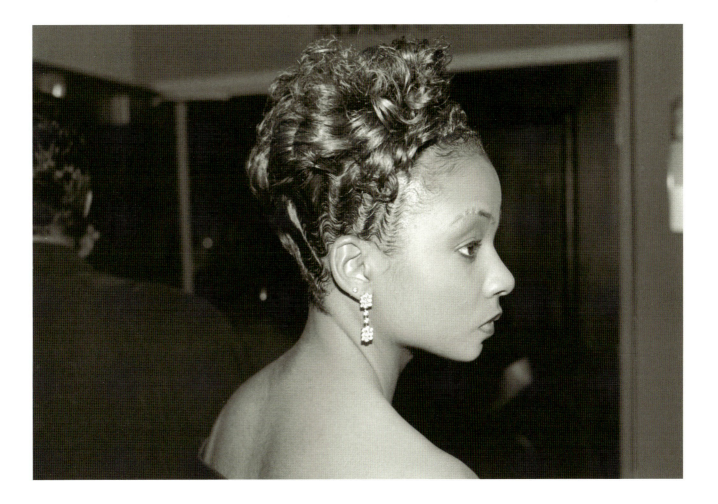

Bill, Bronner Brothers International Beauty Show, Atlanta, Georgia, 1991.

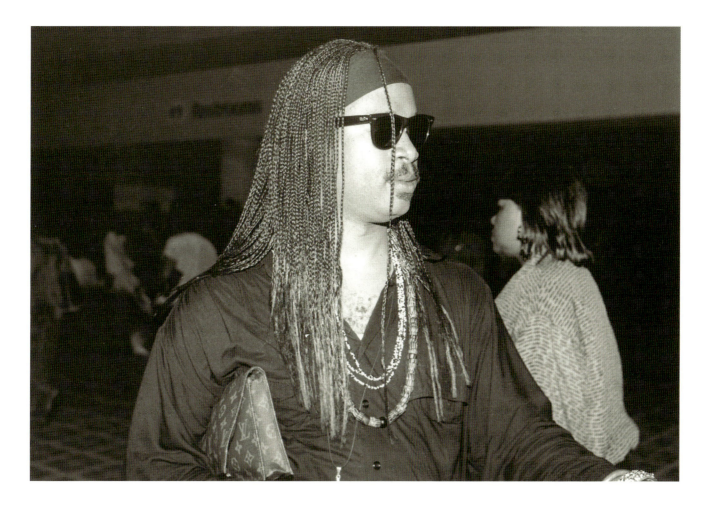

Dee, World African Hair Care, Braid, and Trade Show, Atlanta, Georgia, 1997.

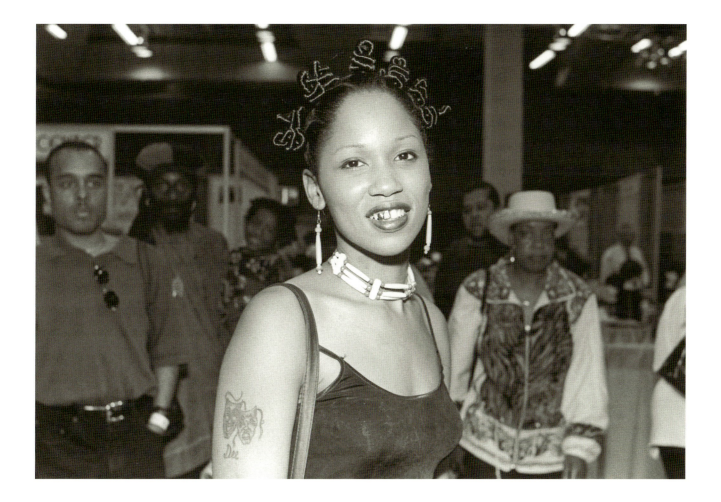

Mellisa, Penn Relays, Philadelphia, Pennsylvania, 1994.

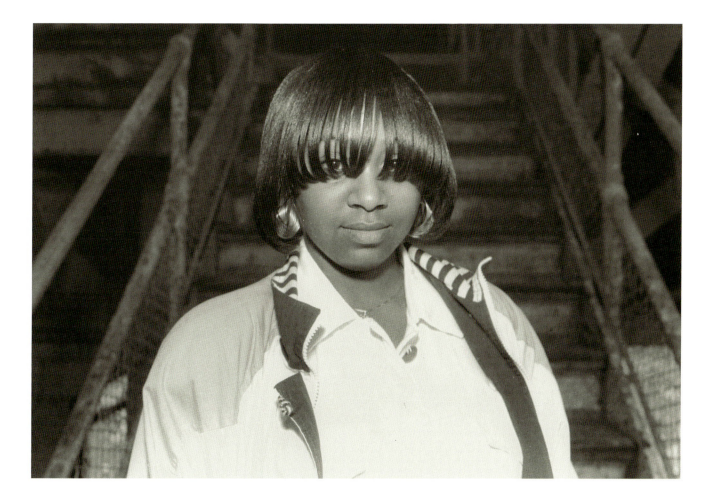

Stylist's model, Spring Hair Show, Columbus, Ohio, 1991.

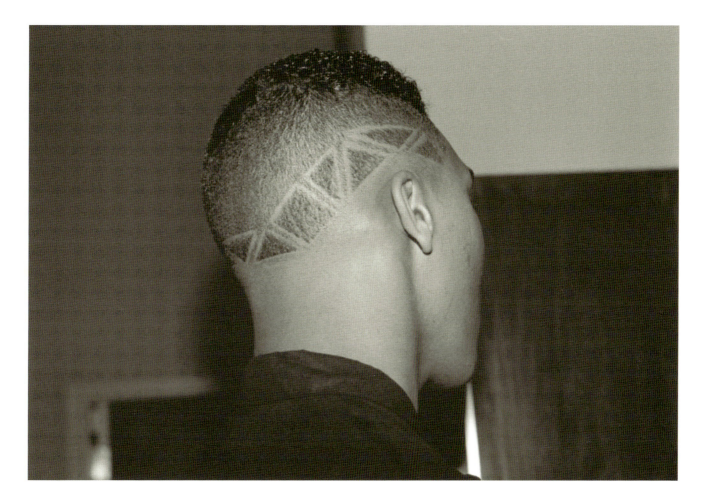

Ebony, Easter Sunday, Kansas City, Missouri, 1997.

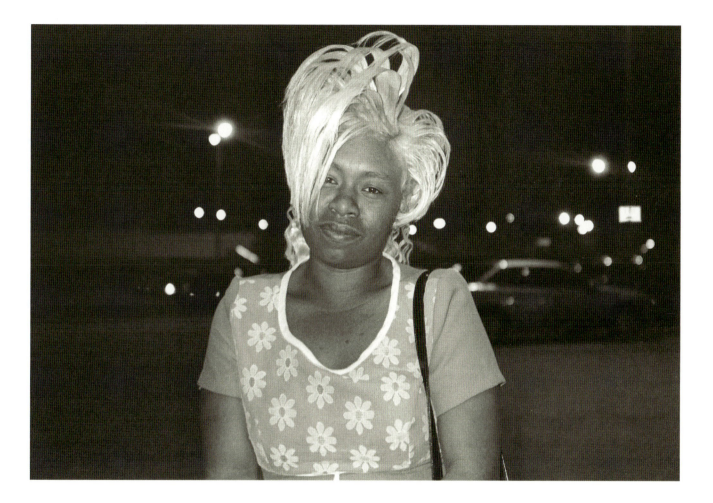

Chris, Ohio Stadium, Columbus, Ohio, 1990.

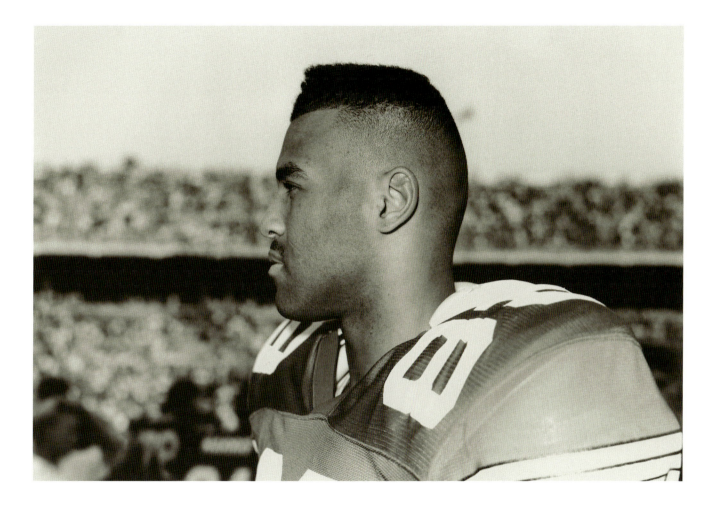

India, Bronner Brothers International Beauty Show, Atlanta, Georgia, 1991.

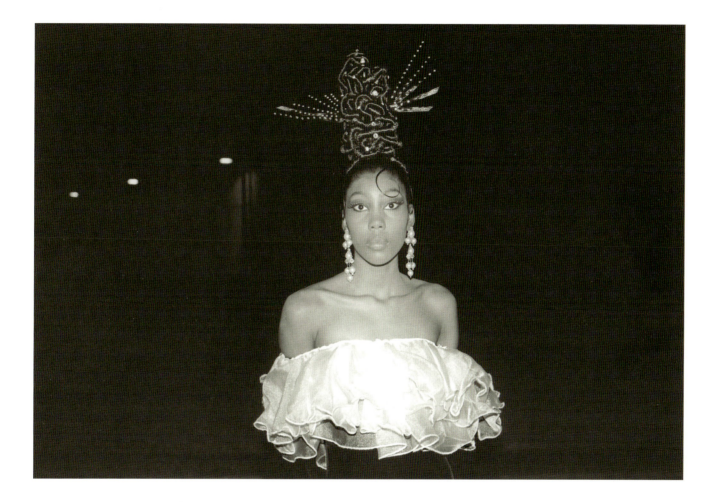

Toni, Chicago, Illinois, 1994.

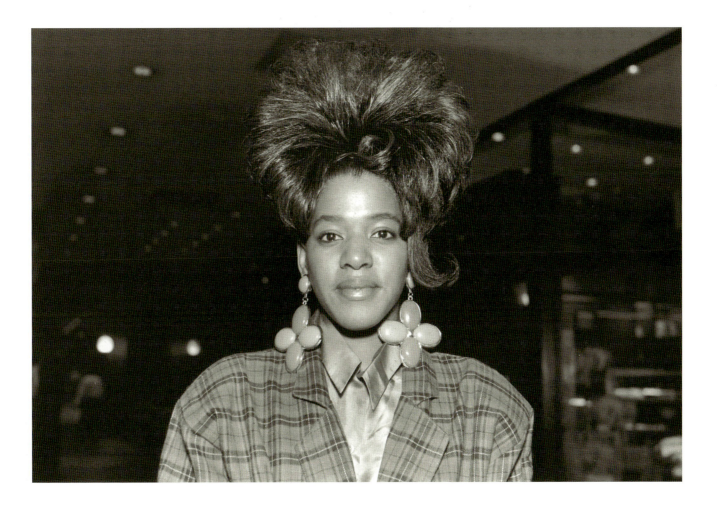

Japonica, Baltimore, Maryland, 1994.

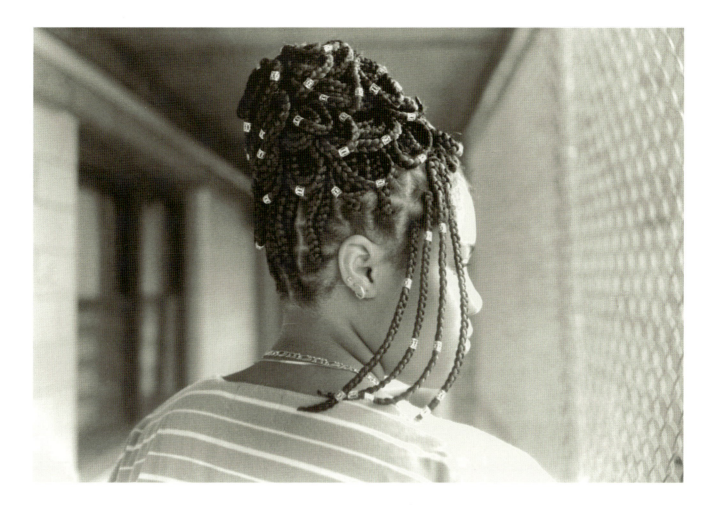

Pat, Baltimore Convention Center, Baltimore, Maryland, 1994.

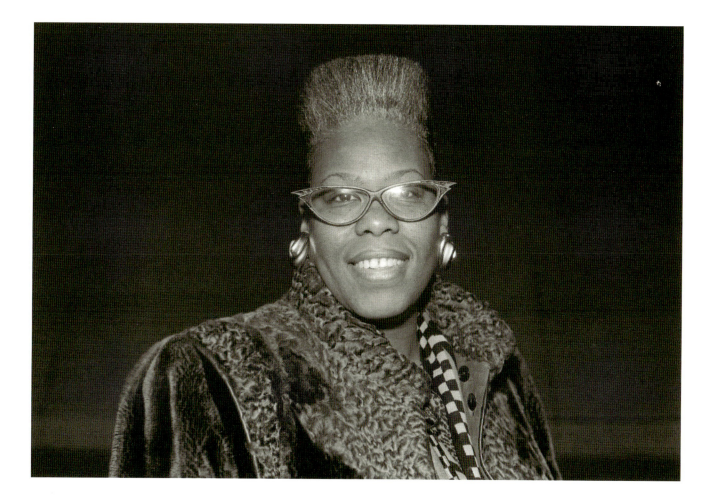

Stylist's model, Proud Lady Beauty Show, Chicago, Illinois, 1994.

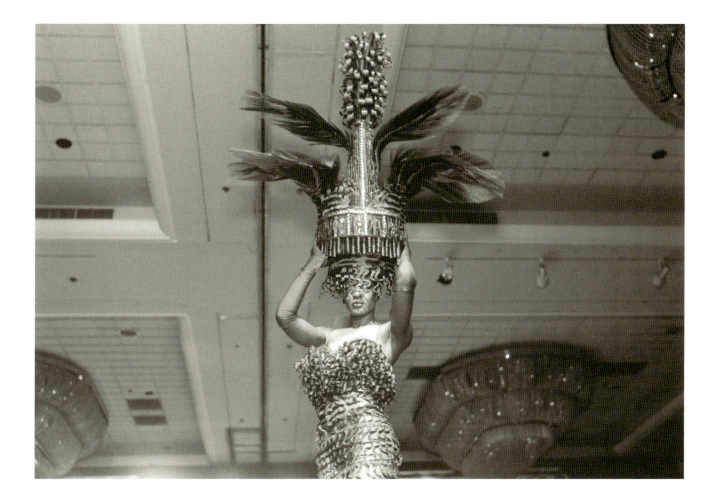

Men at Black Greek Picnic, Philadelphia, Pennsylvania, 1991.

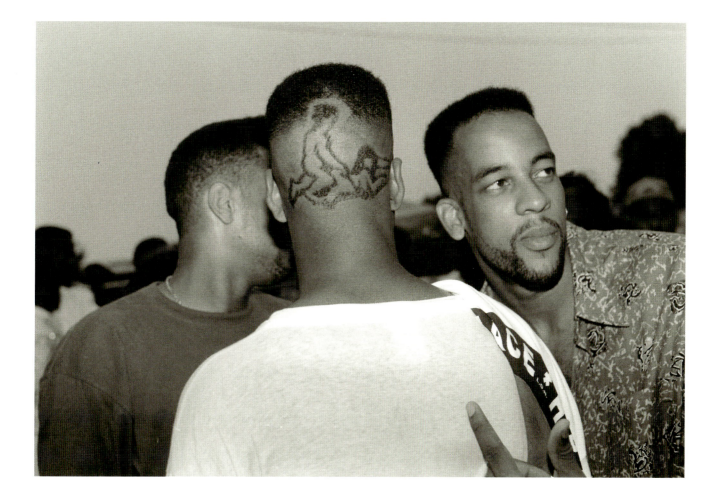

Nissa, Park Slope, Brooklyn, New York, 1996.

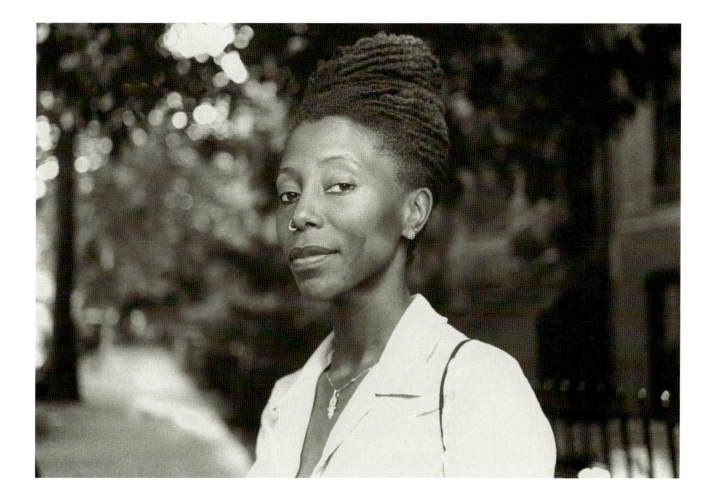

Tamara and Tireka, Easter Sunday, Baltimore, Maryland, 1995.

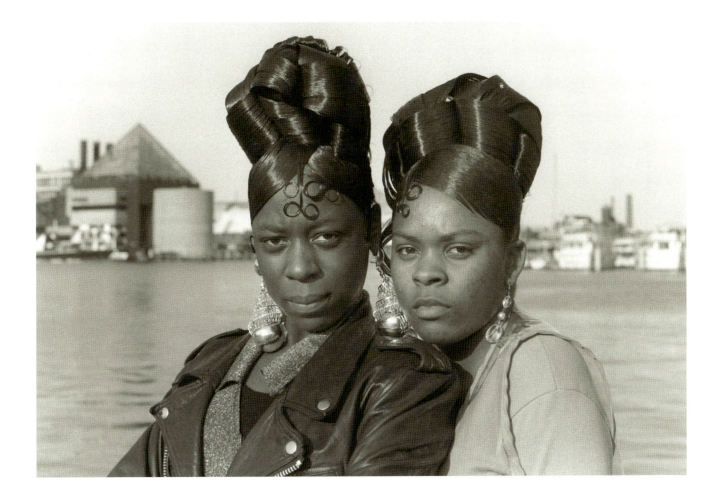

Bridget, Atlanta, Georgia, 1991.

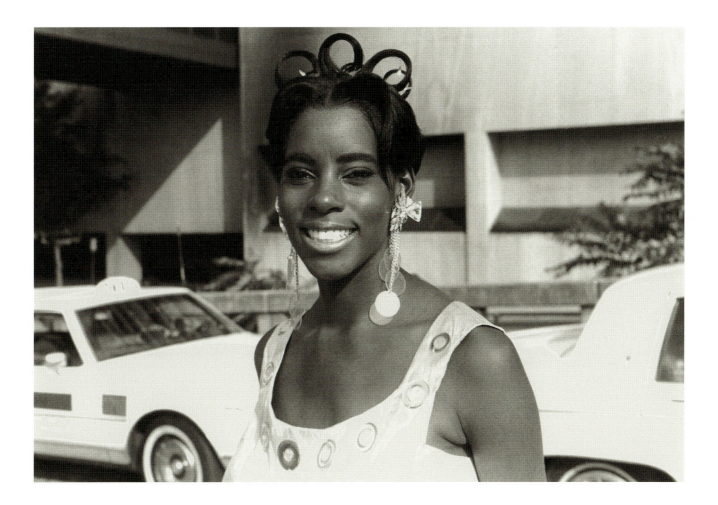

Ronald, Proud Lady Beauty Show, Chicago, Illinois, 1994.

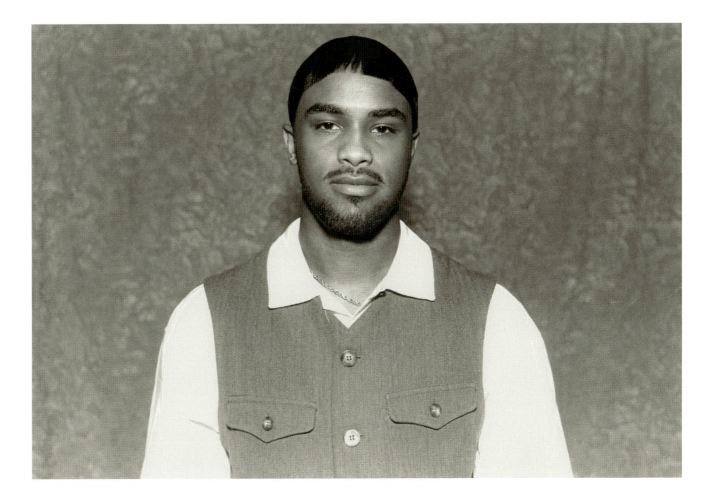

Paula, Black Greek Picnic, Philadelphia, Pennsylvania, 1991.

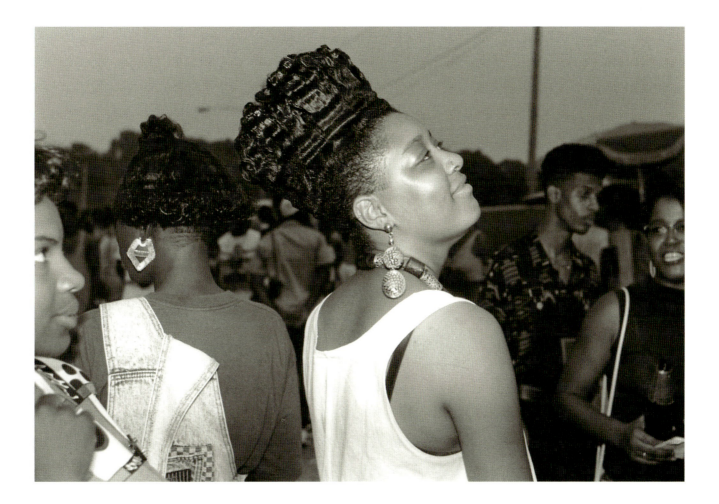

Stylist's model, International Beauty Show, New York, 1994.

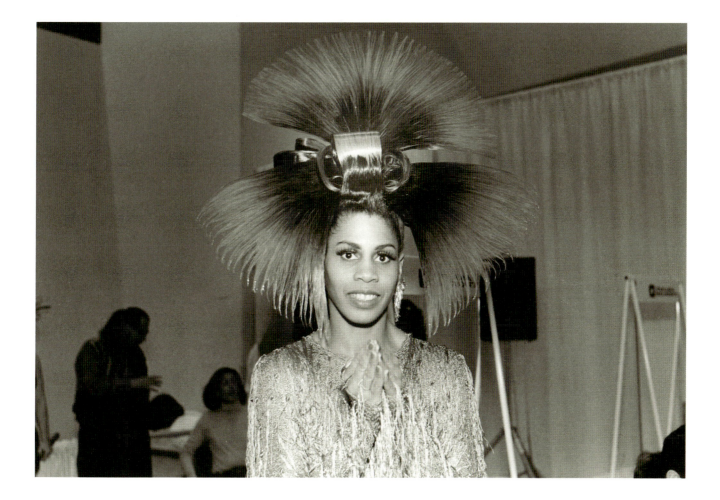

Tanya, Baltimore, Maryland, 1994.

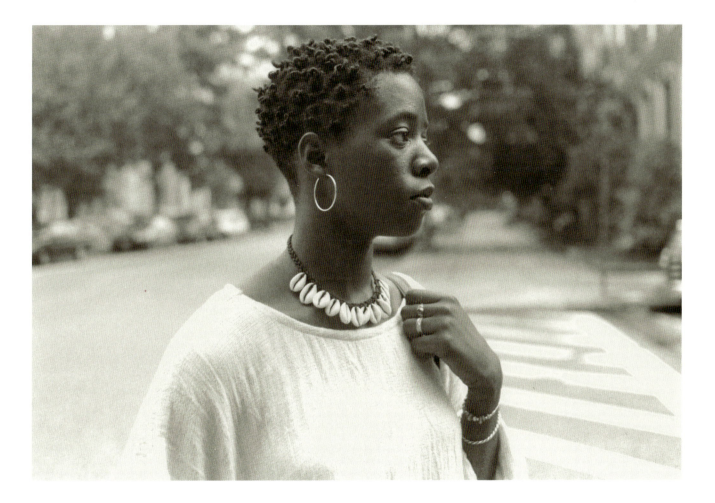

Stanley, Bronner Brothers International Beauty Show, Atlanta, Georgia, 1991.

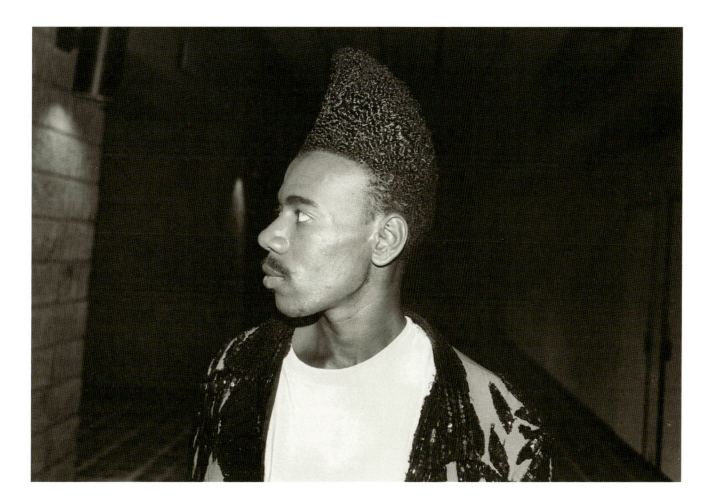

Acquinetta, Baltimore, Maryland, 1997.

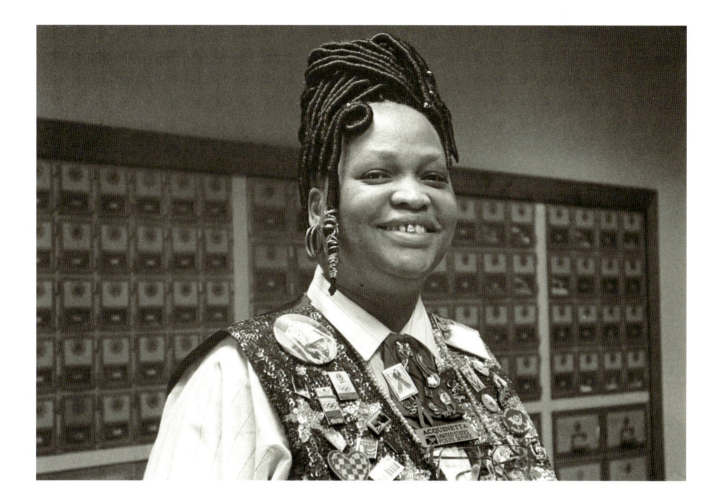

Kirk and Coke, International Beauty Show, New York, 1994.

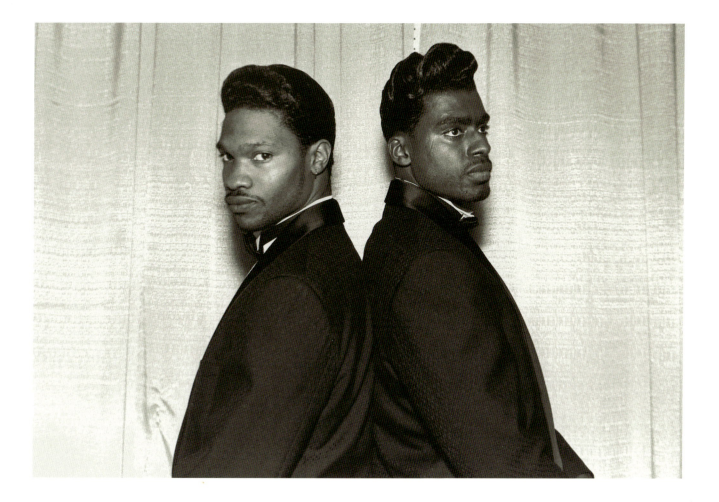

Tiny, Artscape Festival, Baltimore, Maryland, 1993.

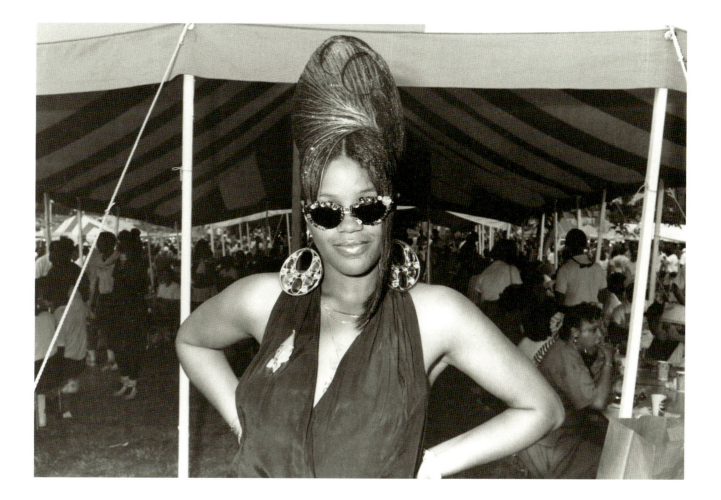

Man at Artscape Festival, Baltimore, Maryland, 1993.

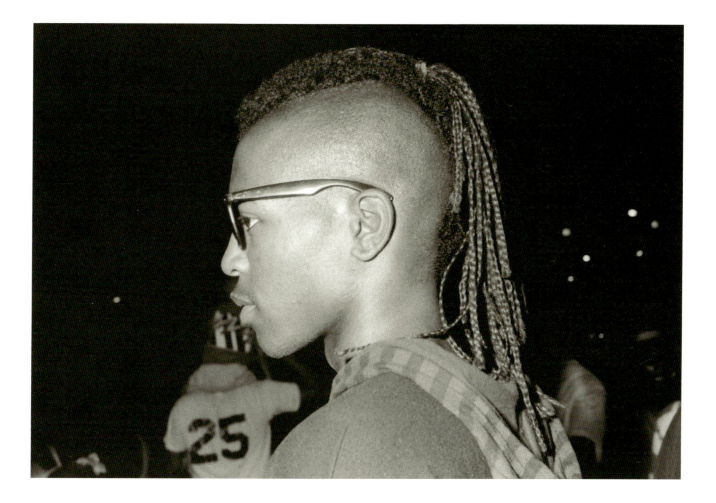

Stylist's model, Spring Hair Show, Columbus, Ohio, 1991.

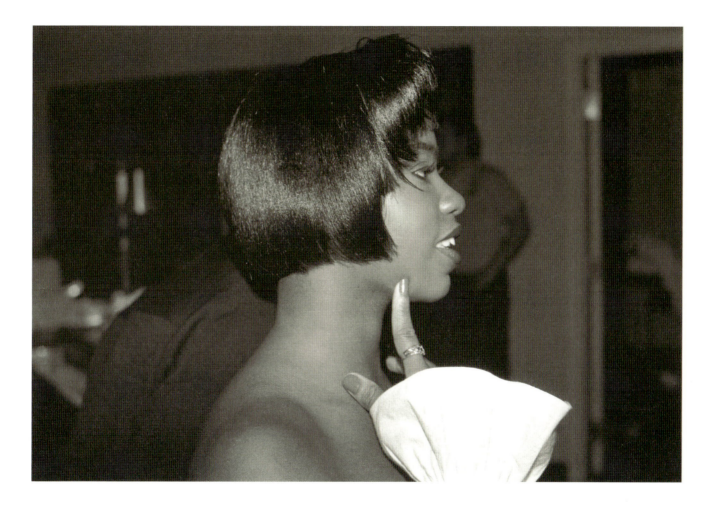

Jelani, World African Hair Care, Braid, and Trade Show, Atlanta, Georgia, 1997.

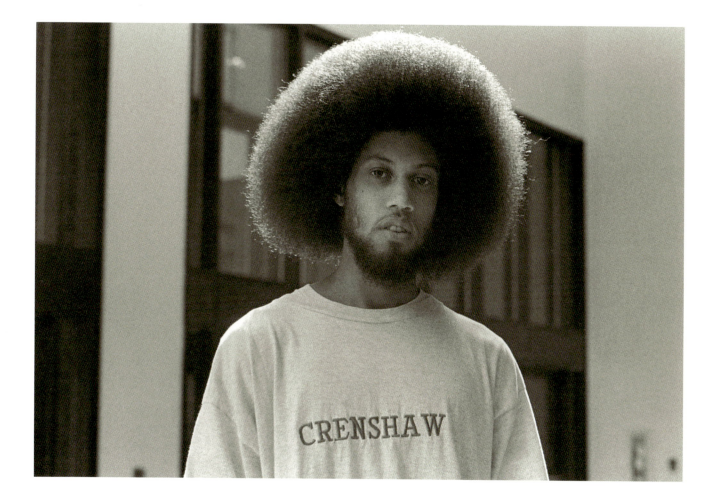

Inezz, Columbus, Ohio, 1994.

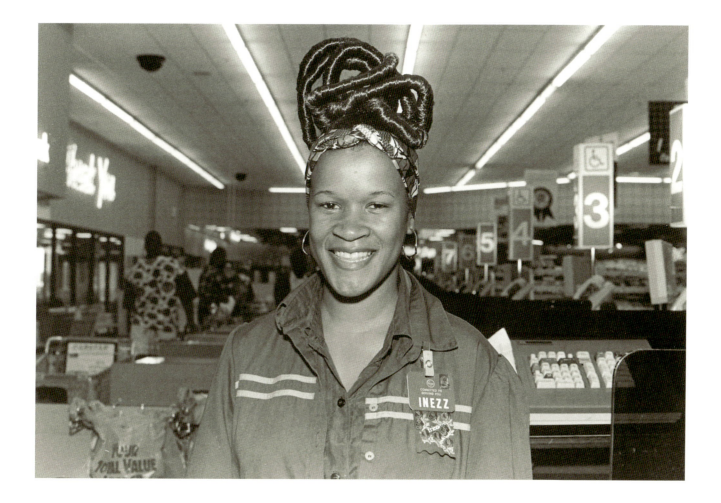

Kris, World African Hair Care, Braid, and Trade Show, Atlanta, Georgia, 1997.

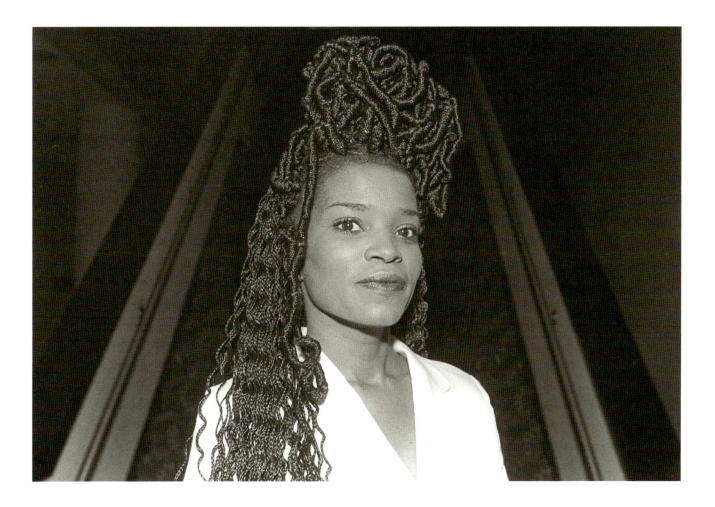

Thomas, Chicago, Illinois, 1994.

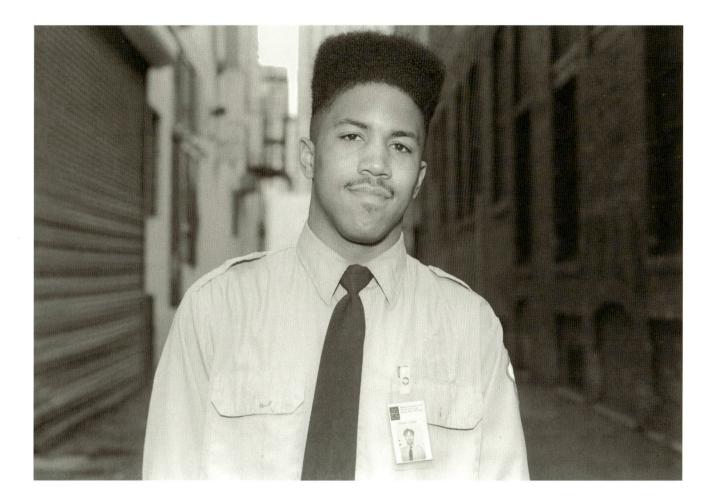

Espi, Baltimore, Maryland, 1993.

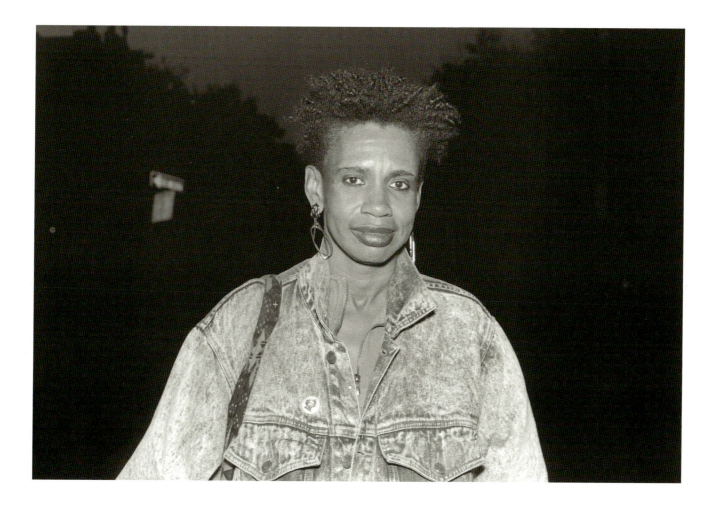

Man at Bronner Brothers International Beauty Show, Atlanta, Georgia, 1991.

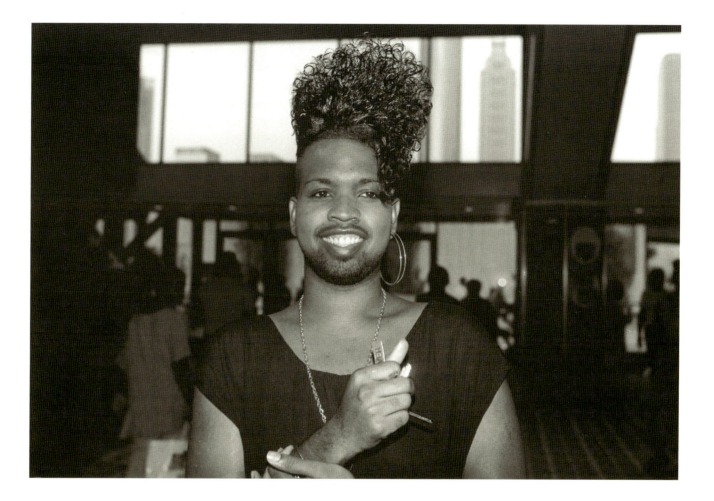

Red, World African Hair Care, Braid, and Trade Show, Atlanta, Georgia, 1997.

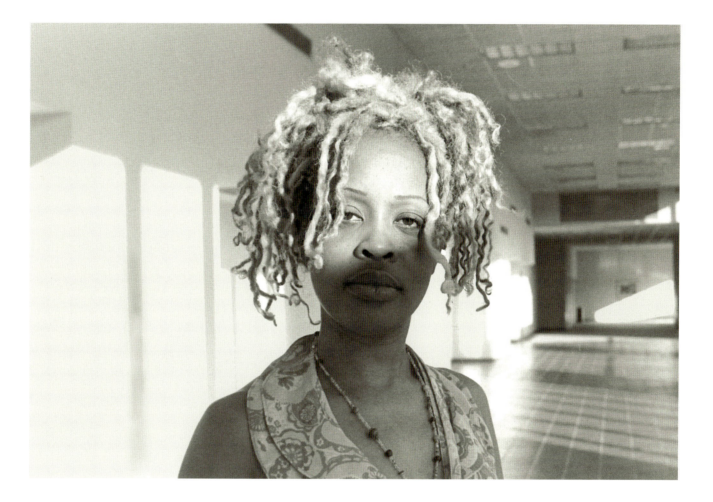

Arrogant, Proud Lady Beauty Show, Chicago, Illinois, 1994.

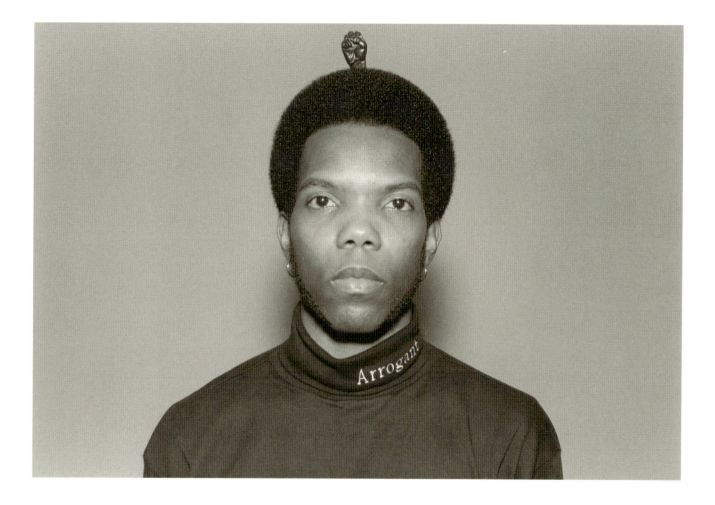

Tasha, World African Hair Care, Braid, and Trade Show, Atlanta, Georgia, 1997.

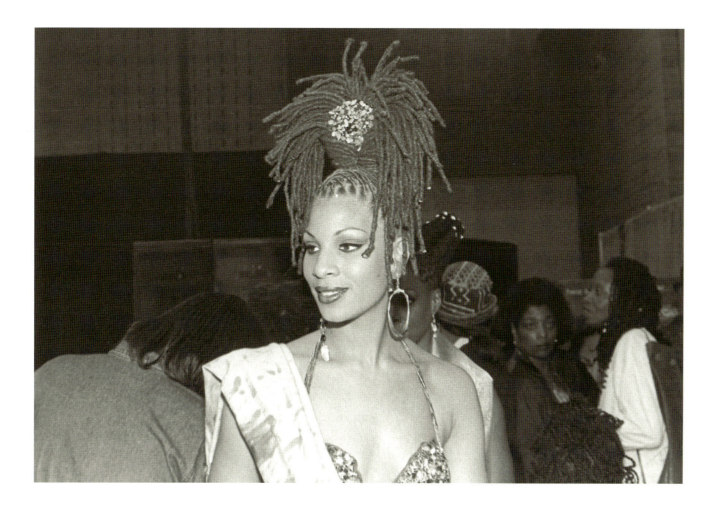

Stylist's model, D.C. vs. Philly Hair Show, Philadelphia, Pennsylvania, 1994.

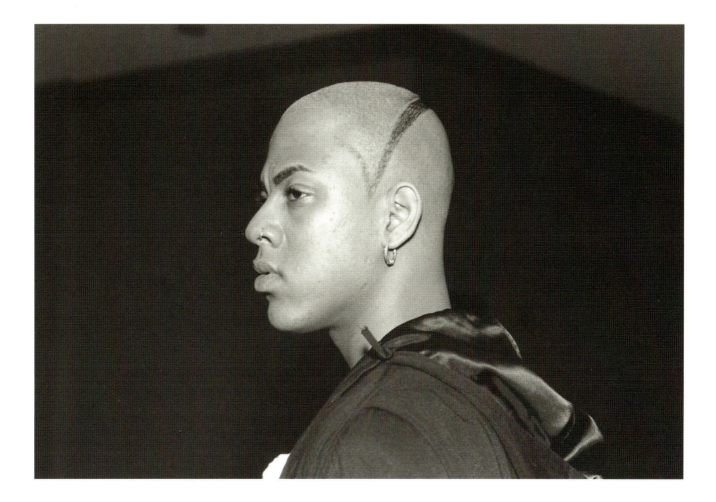

Ava, Atlanta, Georgia, 1997.

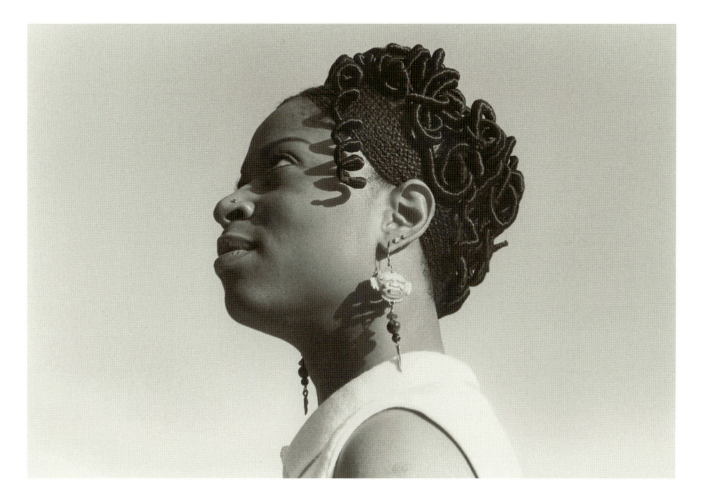

ABOUT THE PHOTOGRAPHS AND TEXT

Bill Gaskins is a visiting artist and assistant professor of Art and African American studies at the University of Missouri-Kansas City. Before assuming his current position, he served as a visiting artist in the department of photography at the School of the Art Institute of Chicago. His photographs have been widely exhibited across the country.

Nikky Finney works and writes in Lexington, Kentucky, where she is a founding member of a community-based writing collective, The Affrilachian Poets, and associate professor of creative writing at the University of Kentucky. She is the author of two collections of poetry, *On Wings Made of Gauze* (1985) and *Rice* (1995). Her poems have also appeared in the anthologies *In Search of Color Everywhere* and *I Hear a Symphony*.

Author photograph copyright 1991 by Scarlet Quick.